C000050189

Intermediate Guide to Ceramic Glazing

Gill Roy

© Copyright 2019 - All rights reserved.

The content contained within this book may not be reproduced, duplicated or transmitted without direct written permission from the author or the publisher.

Under no circumstances will any blame or legal responsibility be held against the publisher, or author, for any damages, reparation, or monetary loss due to the information contained within this book, either directly or indirectly.

Legal Notice:

This book is copyright protected. It is only for personal use. You cannot amend, distribute, sell, use, quote or paraphrase any part, or the content within this book, without the consent of the author or publisher.

Disclaimer Notice:

Please note the information contained within this document is for educational and entertainment purposes only. All effort has been executed to present accurate, up to date, reliable, complete information. No warranties of any kind are declared or implied. Readers acknowledge that the author is not engaging in the rendering of legal, financial, medical or professional advice. The content within this

book has been derived from various sources. Please consult a licensed professional before attempting any techniques outlined in this book.

By reading this document, the reader agrees that under no circumstances is the author responsible for any losses, direct or indirect, that are incurred as a result of the use of information contained within this document, including, but not limited to, errors, omissions, or inaccuracies.

Table of Contents

Introduction

In this book, I will delve a little deeper into the art, looking at slightly more complex techniques and concepts, and going into deeper details on other subjects. The purpose of this book is to bring your ceramic art to new heights and ascend beyond the classification of a beginner.

I've put a lot of effort into making this book as simple and easy to understand in the hopes of making ceramics feel more fun. I know very well how tedious it can be to read through pages and pages of complex explanations and descriptions that teach me barely anything that I can apply practically. Still, sometimes explanations of how something works are necessary. In those cases, I've done my best to sum them up into only the most important facts and to keep the terms as simple and straightforward as possible.

Still, you don't need to be a master of the arts with years of experience before you use this book. As long as you've got a good understanding of the basics of pottery glazing and enough knowledge to tell the difference between bisqueware and greenware, you have

enough experience to use this book to its full potential.

Chapter 1

Before You Start

The most important thing to do before starting a ceramics project is to plan. No matter how great your skills are, or how much experience you have, if you don't plan, you won't be able to get the best out of your work. You can never do enough planning, and even if you end up doing something that wasn't part of your planning, your planning will still have helped you get a better idea of what you wanted.

The first step of your planning is deciding what you want to do. Whether you're making a pot, bowl, tea set, or decorative sculpture will affect every aspect of your planning, such as your clay, technique, time management, and the type of design you want to work with. Once you've decided on what you're making, you can go on to plan when you're going to create your work, making sure you have enough time scheduled for each phase of the process.

Once you've decided what you want to make, you need to choose your method and your

clay type. This is a very important part of the planning, as certain types of clay work better with different methods, and the clay type may have an influence on your glaze as well. At the end of this chapter, I will give you more information on the properties of different clays and glazes to help you with this.

You now have two choices. You can either immediately plan your glaze, or you can make the piece and plan the glaze while you're waiting for the clay to dry. The advantage of planning your glaze before starting with the clay is that you'll have a better idea of the final product throughout the whole process, and it may be easier to work towards that final goal. On the other hand, having the physical piece in front of you may help you better visualize how your glaze will look on the specific shape, and as it often happens, a piece may not end up in the exact shape you originally planned; you might prefer to create a design to match your final shape, rather than adapting the one you've already made. However, both options are fine, and it's up to you to see which works best for you.

Regardless of when you're planning the glaze, the basic process is the same, and once again choosing what you want. Do you want a solid color, randomly mixed colors, patterns, or a detailed image? These questions are

important, as they will determine the type of glazes and application techniques you'll use. For a single color or a gradient from light to dark, a dip might be better. For a simple, repetitive pattern, you may want to consider a stencil or reverse stencil, and for a more detailed piece, painting maybe your best option. Once you've made up your mind on the type of design, application technique, and glaze type, it's time to choose your basic color schemes. It's ok if you don't know the exact shades and colors you want to use, as long as you have a vague idea of the color types, such as light blues for a calm, cool feeling piece, greens and browns for nature-inspired works, reds and yellows for something fiery and exciting, or bright, contrasting colors for a dramatic piece. You can refine your color palette as you go on, and you may want to experiment a little with your colors on test tiles.

Once you have an idea of your color scheme, you should choose your base color to form the background. Then it's just a matter of playing around a little. Draw out your ideas for designs on a piece of paper, using pencils. You also don't need to come up with a complete design all at once. Play around with different ideas, line types, etc. and see what you like. You can also play around with different colored pencils to see which colors you like. You also

don't need a perfect, complete design. You may be the type of person who likes to go with their instincts and work without a definite plan. In those cases, having a very basic design or mood board can help you guide your thoughts in the right direction when the time comes. Many artists have their own design process, as should you. Designing the look you want for your glaze should be centered on your own creative processes.

Designing your glaze for layering can be a little more time consuming and complicated, as you will have to put effort into planning every layer, but it can save you a lot of effort in the long run and can help you prevent mistakes. One of the most effective ways to plan for layering is to draw out the final design you want, then analyze it and divide it into separate layers. You may want to draw out each layer to make sure you know what you're doing when it's time to apply your glazes.

Something else to keep in mind is that glazes can be opaque or translucent, thick or thin, textured or smooth, shiny or matte, and they may affect each other when applying in layers. As a part of your planning, you should test out the glazes you want to use. The best way to do this is through test tiles. You can also use this as an opportunity to experiment with

mixing colors and getting different effects through layering. This way, you'll know exactly what to expect from your glazes.

Another element to look carefully at when planning is deciding which areas to wax. A big mistake many beginners make is to not wax their bisqueware before glazing. This is vital, as your bisqueware will be fused to your kiln. Always wax any surface of your bisqueware that will be in contact with your kiln and make sure it's clear of any glaze. A fused glaze won't only ruin your bisqueware, but it can also damage your kiln.

Once you're happy with the design and satisfied that you've done enough planning, you can get started on your next masterpiece.

Clay and Glaze Properties

The properties of the glazes and clays you use have a significant influence on the whole process of creating your ceramic work, so it's important to make sure you understand at least the basics.

The main element that separates clay from regular sand or mud is its plasticity. This term refers to the clay's ability to form a solid mass and maintain its shape when wetted with the right amount of water. The clay will not lose its

shape once it dries or is baked. The plasticity, as well as the amount of water needed to achieve it, is a big part of how clay is classified into different types. The level of plasticity also has an influence on the final result of your work once it is bisqued and fired. Another unique quality of ceramic clay is that certain components within the clay melt, fuse, and solidify, forming a hard, glass-like quality we want in our ceramics. The temperature at which the clay needs to be fired to meet these components is also an important factor in classifying clay types.

There are three types of clay commonly used called earthenware clays, stoneware clays, and ball clays, which are very easy to come by in stores in both dry and moist form. Two other types that are slightly rarer but still popular are fire clays and kaolin clays.

Earthenware

Earthenware is the most common type of clay, as well as the easiest to work with, making it great for beginners or for experimenting with new techniques. It's the best clay to work with when using the potter's wheel or RAM press. Earthenware clays contain components that melt at fairly low temperatures, meaning they need to be fired at low or mid-range temperatures. They also come in various shades

of brown, red, and yellow. The biggest problem with these earthenware clays is that they are fairly brittle, and the baked pieces break fairly easily compared to other clay types. As such, the clay is usually applied fairly thickly. Another problem is that earthenware pieces are also very porous and need to be glazed specifically for waterproofing.

Stoneware

Stoneware clays tend to be a bit less plastic, but are still great to work with. This is also a clay suitable for those less experienced, though not as great as earthenware. True to the name, stoneware tends to vary between white, various shades of grey, and sometimes brown. Different firing methods can be used to alter the colors of the fired piece. Fired stoneware is extremely hard and smooth, but needs to be fired at high temperatures. Stoneware also isn't porous, so you won't necessarily need to glaze it specifically to waterproof it. Stoneware clays are also very popular when it comes to industrial pottery work.

Ball Clay

Ball clay is extremely plastic, contains almost no impurities, and is fired at high temperatures. It usually has a very lovely white, buff or light grey color, which makes it very

popular, and produces a very smooth surface. Although ball clay is very easy to shape and work with, it does shrink quite a lot when firing. If you don't take that into account when shaping your piece, it may ruin weeks of hard work. Because of the excessive shrinking, ball clay is often added to other clays, such as stoneware, to make it more plastic and easier to work with, rather than using pure ball clay.

Fire Clay

Different types of fire clay tend to vary greatly in their general properties, but this type of clay is best known for the extremely high temperature at which it's fired. Fire clay varies in color as well, but usually has black spots caused by iron fragments in the clay. This is often considered to be a very great visual feature. Fire clay is often added to other clays to increase their maximum firing temperature, or to smooth clays, such as stoneware, to give them a rougher texture. Fire clay is also often used to make cones that are used in a fuel kiln to help determine the temperature.

Kaolin Clay

Kaolin clays have very few or no mineral impurities and are thus used for porcelain works. Kaolin clays tend to fire into very light grey, white, or off-white colors. Despite how

beautiful these types usually are, kaolin clay isn't very plastic and is very hard to work with, which is why porcelain is so expensive. It also fires at temperatures that far exceed those of stoneware and fire clay. Potters often mix other clay into kaolin clay to make it easier to work with and to lower the temperature it needs to be fired at. In many cases, a porcelain body is a mixture of kaolin and ball clay.

There are various types of glazes throughout the world, often determined by color and texture, but there are a few other very important properties that are looked at when it comes to glazes, especially in terms of appearance.

Opacity

This refers to the glaze's ability to let light pass through it, or in simpler terms, how see-through the glaze is. If a glaze is completely solid and you can't see through it at all, the glaze is called opaque, while a completely clear glaze is called transparent. Translucent is a term that refers to a glaze that is neither fully transparent or fully opaque, but somewhere in between. There are many uses and effects for these glazes. Opaque glazes are most commonly used as base colors and for painting on designs and patterns. Transparent glazes are most commonly used as

a top coat to seal the design, create unity, or add depth. It is also the best option if you want your glaze to waterproof your work. Translucent glazes are the best way to create new colors through layering and can have some interesting effects when used creatively.

Reflection

Everything reflects light, and the intensity of this reflection determines if something is gloss or matte. The more light the glaze reflects, the glossier your glaze will be. Matte, on the other hand, reflects much less light. Matte and gloss glaze can be used to get some really great effects, especially if used in combination, but keep in mind that if you use a gloss clear glaze as a top coat on a piece that has a matte glaze, you will lose the matte effect to some extent. The same goes for using a matte clear glaze over a very glossy glaze. A clear matte glaze is the absolute best option if you want to seal or waterproof your clay while altering the appearance of the clay as little as possible. Satin refers to a glaze that is somewhere between a gloss and matte.

Texture

Although most glazes are generally smooth, many glazes are created to give a specific texture to your work, such as glazes that

form cracks or ripples as they dry, or more subtle textures that are just a little grainy or rough. Textures are a great way to add to the look of your work, and you can even combine different textures. The thickness of your glaze also has an impact on the texture of your gloss, and a thin glaze works better if you want to keep the texture of the clay intact as long as possible. You can also use thicker layers of glaze to fill in unwanted texture in your clay. This will, however, take longer to dry, and it will affect the color greatly, especially if you're using a more transparent glaze.

Color

This is the property potters look at the most when choosing a glaze. There's an extremely large variety of colors available on the market, and an infinite selection if you're making your own. Some glazes are created to work with a slight gradient effect, which contains small particles of other colors or minerals that react differently than the rest of the glaze when fired so that you have a multi-colored effect from a single glaze. Glazes can also be mixed together to make new colors, or you can mix your own colors once you understand the basics of powdered glaze recipes. There are almost no limits to the color

range of your glazes, even with transparent or translucent glazes, beyond your own creativity.

Chapter 2

Stains and Oxides in a Glaze

Oxides and stains are a great way to play with the color and texture of your work. These two are very similar, but they do have some differences.

Stains are a type of glaze designed specifically to emulate the fired color. Unlike regular glazes and oxides, the stain won't l change color as it fires. Stains are also a bit safer to use than oxides, as they contain fewer toxic chemicals and can create almost precisely the same result every time when mixed with water. It's also easier to fine-tune the exact shade and hue you want. Stains may be a bit more expensive than regular glazes and oxides, and they tend to be a little more difficult to dissolve in water, but they can save you a great deal of time and effort, which can be an exceptional help. Stains can be applied using the same

techniques as regular glazes. Stains can even be mixed with glazes for a thicker substance.

Stains are created by melting ceramic oxides and coloring oxides together in a kiln. This mixture is then quenched and ground into a fine powder. These powders are then mixed with organic colorants and dissolved in water to form a stain. Because the oxides have already been fired once, they have already undergone the chemical reaction that comes from exposure to heat and will not change color when firing the pot. The stain powder can be used in regular glaze recipes as a colorant as well as being used on its own. You can also use a stain over dried layers of glaze, or use glaze over dried stains. Stains can also be applied fairly thin to help maintain the texture of your clay.

Oxides are one of the main ways to color your glaze, and often form the basis around specific color recipes. However, oxides are very different from glazes. Glazes are a mixture of different chemicals and compounds, usually with a high silica content, but oxides are made up of one single component, which is usually metal based. Oxides are one of the easiest ways to cover your piece easily in a solid color, as the oxides won't move to fill deeper spaces and form natural highlights during firing the way glazes do. Oxides can often cause a chemical reaction

when exposed to heat, and as such, your glaze may have become a completely different color after glazing. This can be used to your advantage, but it needs to be tested and taken into consideration in your planning.

To use oxides, you will need to create an oxide wash. To do this, simply mix a little bit of your oxide powder with water. Oxides have very strong color pigments, so you will only need a small amount of oxide. You may need to experiment with the oxide to water ratio to find the right intensity of color. The ratio results in a very thin and watery mixture, making it a wash rather than a glaze. The wash will dry much quicker than a glaze and isn't applied as thick. Oxide washes will also result in a dry, matte look for your work and will not help waterproof your earthenware pieces. When using oxides, you need to stir your wash very often, as the oxide particles are heavy and will separate from the water and settle on the bottom of your container very quickly. Otherwise, oxide washes can be applied using the same basic application methods as glazes, such as painting, dipping, wax resists, etc.

One great advantage of oxides and oxide washes is that you can use them to greatly enhance the details in your bisqueware. Normally, the oxide wash will coat your piece

evenly and result in a solid color, making it hard to make out any details. But you can use a cloth or piece of paper towel to gently wipe over the piece. This will remove a bit of the pigment from the raised surfaces while leaving all the pigment in the deeper areas like carved lines and corners. This will also help remove excess wash that may run while firing and fuse to your kiln shelf. Raw clay will absorb the wash a little more than bisqueware, meaning the effect will be a little less intense, but the technique still works on both raw and bisqued clay. If you want to strengthen your effect, simply use a fine brush to add more wash to the areas you want darker and wipe over the piece again. You can also add more layers to your piece. It will be more effective if you let the first layer of wash dry slightly, and remember that the wash will take longer to dry on the areas where it's thicker. Oxides can also be mixed into your glaze to get a similar effect, as the oxides will settle in the deeper areas as the glaze dries.

Oxides face similar application problems to glazes, such as oily fingerprints or bisqueware that has been over-fired and become partially waterproof. Another minor problem is that you can end up with fingerprints where you hold your piece while applying the oxides, especially when dipping the piece. Luckily, there are

cheap, easy to come by tools such as finger sheaths or tongs that can help you solve this problem.

Another great use of oxides is to create patinas. A patina is a thin layer of wash or stain that adds color to the work, while still keeping the texture of the clay itself visible. This can result in very beautiful and interesting pieces, and is very easy to apply in a few simple steps:

1. Bisque your work and let it cool before applying a patina, as raw clay will absorb the patina too much.

2. Mix your patina, wash, or stain, and moisten an old sponge.

3. Working in small sections at a time, apply your patina in a thick layer.

4. Before your patina dries, gently rub the patina off your work, making sure you remove as much as possible. By applying your patina very thick, you will force the color into the pores that create the texture, which will not be removed, emphasizing the texture.

5. Keep repeating steps 3–4 until your entire pot is covered.

6. Let the patina dry. Add a layer of clear glaze if you want.

7. Fire your pot.

Patina is a great way to add an aging effect to your work, and can easily be applied over another dried stain or oxide wash, or even a glaze if they've been applied thinly enough.

Chapter 3
Underglaze wash

U nderglazing is a technique that refers to applying glazes to create decorative designs and images on the surface of your clay, be it a simple, repeating pattern of lines and dots, or an intricate work of art. Underglazes refer to the materials applied to the clay, such as colored glazes, slips, stains, etc. There are, however, glazes that have been created specifically for underglazing, which is called an underglaze. You also get more specialized tools, such as underglaze pens that can make applying an underglaze easier and more convenient. There are also many recipes for making your own glazes.

Although all application techniques are suitable, the most effective and controlled method is still painting. Another great method is to use an underglaze wash. The biggest difference between a glaze and a wash is that a wash is much thinner than a glaze, as a lot more water is used to mix the wash. You can also thin

a glaze out a little by adding water to create your own wash. The main use for washes is to bring out the detail and texture in carved and stamped bisqueware, much like oxides and stains. There are a few easy steps to do this.

1. To start off, brush a few layers of the wash onto the bisqueware and let it dry slightly. Many potters prefer to use a sponge rather than a regular brush for this.

2. Using a damp cloth or sponge, wipe off the wash. Make sure you don't use too much pressure and remove all the wash on your clay. You will see that the wash has collected in all the deeper, carved areas of the clay, making them darker and more prominent. The wash will also have left a faint stain on the clay which will be more noticeable.

3. Add new colors of wash if you want and let them dry slightly.

4. Wipe the wash off again, but use significantly less moisture and pressure if you want to keep more of the wash color on your clay. Also be careful not to wipe over the same area too often, as the moisture will make the lower layer of wash wet again and muddy the colors.

5. Bisque the pot again for a few minutes if you plan on adding glazes to the pot over the wash.

Washes are also great for using stamps on pottery work, and you can get a great watercolor effect when painting with a wash. You can use washes over regular glazes and stains, but if you want to apply a clear glaze over a wash, you need to work carefully and use light brush strokes, as the liquid in the glaze might activate the wash again and drag some of the color and pigment with it as you brush on the glaze.

Chapter 4
Soluble Salts

Soluble salts are minerals, such as magnesium sulfate or calcium, found inside your clay, which will dissolve into your clay once moistened. These soluble salts can have interesting effects on your clay, which can be positive or negative, depending on how you use them. Soluble salts can also be used in your glazes, to create interesting new effects. When using soluble salts in your glazes, the soluble salts will be absorbed into the raw clay or bisqueware, taking the glaze with them and creating a visual effect similar to using watercolors on paper. Most soluble salts are metal by nature, such as chrome, cobalt, and copper.

In essence, you mix a soluble salt with a clear glaze stain or wash. The type of soluble salt will determine the color of your glaze, and the amount will determine the intensity of your color when fired. Glazing with soluble salts works similar to glazing with stains and washes

and is most commonly done through painting. Because the soluble salt mixture is so thin and runny, it can be difficult to work with, especially when creating patterns and designs. Because the colors are so thin and translucent, advanced layering is nearly impossible, as you won't be able to properly cover the color underneath. This in itself can be used to your advantage to create interesting new effects. You will also sometimes have to apply several layers of a single salt wash to get a strong color. These soluble salt washes also work best on white clays, meaning you'll use them on stoneware rather than earthenware. This is also a very popular technique to use on porcelain.

To help you get started, here is a list of some of the most common soluble salts and the colors they can give you:

- Barium: light green

- Calcium: red

- Chrome: brown or olive green

- Copper: blue or green

- Lead: pale blue

- Potassium: violet

- Sodium: Yellow

- Strontium: crimson

You may notice that if you mix these powders with your glaze, not all of the glazes match the color described in the list. This is because the salts have a different chemical reaction to heat than water, and as the piece will be fired, the final color of the salt wash will be determined by the chemical reaction of the salt to high temperatures.

The list provided is very basic, and there are many more soluble salts available. These salts can also be combined to create new colors. You will have to experiment a little to find the soluble salts you want to use for this technique. Although the best way to experiment is through test tiles, a quick way to see the type of color you can expect is to expose the salt to heat. You should always be careful when trying this, as most salts are toxic and highly flammable. Here are a few steps you can follow to flame test a soluble salt safely:

1. To start, make sure you are working in a well-ventilated area. If you need to work outside, make sure your work area is protected from the wind.

2. You will also need some safety gear and special equipment. For safety gear, you will need safety goggles, oven mitts, and a mask

to protect yourself from any noxious fumes and gases. You should also keep a fire extinguisher nearby in case of an emergency. In terms of equipment, you will need platinum or nichrome wire, hydriodic acid, and a source of flame, such as a Bunsen burner or long fire nozzle lighter.

3. To start, clean your wire with the acid to remove any chemicals that may affect your results. Then dip one end of your wire into the salt you want to test. There should be some acid still attached to the wire to help the salt stick.

4. Working carefully, hold the wire with your salt over your flame until the salt ignites. If you've used a small amount of salt, there will be a sudden flare of colored fire that will disappear again quickly.

5. The color of the flame will tell you the color of a fired glaze made with that salt. Note that if you are using nichrome wire, there will always be a hint of orange in the flame together with the color from the salt.

Always be very careful when working with open flames like this and never do this when there are children or small animals in the vicinity. If you do have a small child and do your

ceramic work at home, it's better to test the salt through test tiles alone. Also remember that although the flame test will show you the type of color the salt will create, the salt will still react to the other ingredients of the glaze and the minerals in your clay, so the final results may still be a little different. As such, you should still test each soluble salt glaze before using on your piece to prevent ruining days of hard work and patience.

If you're mixing salts, you should keep in mind that they have chemical reactions to each other as well, and they may not have the color you expect once fired. This is also a technique where you have to try it out and experiment a little before you decide if you like it or not.

Chapter 5
Glaze Layering

Glaze layering is a technique that involves applying several layers of glaze and underglaze over each other to create an image, design, or visual effect on your pottery. This technique can help bring more depth and realism into any work and is fairly simple and straightforward once you understand what to do. In essence, you apply one layer of colored glazes, let it dry, and add the next layer. Keep adding layers until your design or image is complete. You may also want to layer a few layers of the same color over each other to make the color more solid and intense.

Although layering is simple in its essence, there are a few things that should always be taken into consideration. First is the order of your layers, as each layer will cover the next. You need to plan out which layer is further in the back and which is further to the front, as the back layers will be "behind" the layers to the front. To help illustrate my point, I will use the

example of a butterfly on a flower, in front of a patterned background. The first layer would be the base color, followed by the pattern. Next is the flower, and the butterfly would be last, as it's in front of the flower.

Something else to take into consideration is that some colors cover better than others, and it is easier to layer dark colors over white colors rather than the other way around. Some colors, like white and yellow, are especially difficult to work with as they don't cover other colors well and take several layers to do so. When planning your layers, you should always think carefully about which colors you are going to put on top of each other.

Here's a simple guide on how to do layering, using the same example of a butterfly on a flower:

1. Cover the area with your base color. Depending on the object, a dip might be most effective.

2. Let the base color dry completely. Use a glaze or wash to add the background pattern. Let this layer dry completely.

3. Paint the base color of the stem of the flower. You can add some shading and highlights here.

4. Let the layer dry again and add some more details to the stem, such as shadows from the petals, etc. You can also use semi-transparent glazes to do some darker and lighter gradients. Let this layer dry.

5. Paint the base colors of the petals and the center of the flower and let them dry completely. Add some details and shading.

6. Paint the base colors of the butterfly once the previous layer is done. Let it dry and add details to the wings.

7. Once that layer is dry, you can add some final details to the whole thing, such as super highlights and outlines.

8. If you want, you can add a layer of clear glaze over the whole design to give the piece a more uniform look.

9. Fire the piece once the last layer has been completed. If you intend to repeat the design several times across your piece, you can do the same layer of each design at once, i.e. the base color for all the stems, then the details for all the stems, then the base color for the flower petals, etc. This can make your work go much faster than repeating the same process for each design.

Cone 6 Glaze Recipes

Here are two recipes for glazes that are excellent for layering, and need to be fired at cone 6, or mid-range temperatures. Cone 6 is one of the best glaze types for layering as the colors are usually vibrant and the layers work well when placed over one another.

Glaze recipes are usually written down in percentages, to make it easier to adapt the size of a batch. As an example, a recipe may contain 30% silica. In a 100 g batch, that means you would use 30 g silica, while in a 500 g batch you would use 150 g silica.

Chameleon Glaze

Soda feldspar: 46.73%

EPK kaolin: 18.68%

Talk: 14.02%

Zinc oxide: 9.35%

Whiting: 9.35%

Lithium carbonate: 1.87%

This is a dark gray glaze, but becomes lighter shades of reddish-brown when applied thinly. This glaze is also very dark when applied to porcelain. The glaze also becomes more matte depending on how thick you apply it. You can

add 2.80% copper carbonate for a slightly altered color.

Chun Glaze

Soda feldspar: 36.54%

Silica: 32.69%

Whiting: 13.46%

Zinc oxide: 11.54%

Ball clay: 5.77%

This is a light green glaze that works great with layering and can be thinned out for washes or lighter colors. The glaze also becomes fairly dark when applied in thick layers. You can add 0.58% copper carbonate for a slight alteration in color.

Cone 10 Glaze Recipes

Cone 10 is also a very popular temperature for glaze layering, as most stoneware is glazed at cone 10, and glazes created for lower temperatures will overheat and discolor. Cone 10 glazes also tend to react to each other on a chemical level very well and are great for layering in general.

Blue Celadon Glaze

Cluster feldspar: 40%

Silica: 35%

Barium carbonate: 8%

Whiting: 7%

Strontium carbonate: 5%

EPK kaolin: 5%

This is a very strong blue glaze that is fairly matte but does have some gloss to it. You can add 0.5% bentonite or 1.5% Spanish red iron oxide for some slight color variations.

Pier Black Glaze

Cluster feldspar: 43%

Dolomite: 24%

EPK kaolin: 23%

Whiting: 5%

Borax: 5%

This is a very lovely black glaze that works great to add gradients and shading to darken the colors already on your pot. You can add 6.6% cobalt carbonate or 6.6% iron chromate for a slight variation in the hue of thin layers of this glaze.

Chapter 6
Luster Glazing

L uster glazing refers to the technique where a special overglaze is applied over a glazed and fired piece, which gives the piece a very beautiful look, and can bring a piece to a whole new level. Luster glazes come in many different colors and metallic effects, but the most common use for luster glazing is with gold luster.

Gold Luster

In essence, a gold luster glaze consists of very fine particles of gold, suspended in a liquid such as pine oil resin — it must be organic. When applied, the glaze may look a little thin and uneven, but once the piece is fired again it will look more solid. Gold luster may be a little too expensive to cover every pot you make completely, but it's great for decorative accents and patterns. Something to keep in mind is that it is possible to apply luster too thick or thin. If a luster glaze is too thick, it will likely bubble or tear when firing. It can also drip when applied

too thick to a vertical surface. If it's applied too thin, your luster will look streaky, or have a purple color after firing, rather than a full, rich gold. You should also keep in mind that the luster will take on some of the properties of the surface it's applied to, so if you apply it over a smooth, glossy glaze the luster will be smoother and glossier too. If you apply the luster to a matte, textured glaze, the luster will be more matte and textured as well.

Applying gold luster is very simple and easy, and can be done in a few steps.

1. Glaze and properly fire your ceramic piece. Let it cool before proceeding to the next step.

2. Make sure your surface is clean of any dust or oily residue, as that might prevent the overglaze from sticking to your piece.

3. Apply the glaze to all the areas you want to be accented or decorated with gold luster. The best tool to use for this is a brush to paint on the luster.

4. Make sure you don't touch the gold luster while it's still wet, as that might leave marks when firing.

5. Let your luster dry for about 24 hours before firing.

6. Fire the piece according to the instructions of the luster. Let it cool properly before removing it from the kiln.

Firing a gold luster is fairly simple and straightforward, and it's not that different from firing a glaze. One of the big differences is that gold luster releases strong noxious fumes while firing that can leak from the kiln and cause severe headaches. Because of this, you should make sure that your kiln is a fair distance away from your living space and in a well-ventilated area. Lusters should also be fired at lower temperatures than the firing temperatures of your glaze. If you fire the luster glaze at a high temperature, you may risk over firing the piece and causing damage to your initial glaze. Make sure you read the instructions of your specific gold luster brand very carefully to make sure you fire it at the right temperature for the right amount of time.

Chapter 7
Decals

Decals are a great tool for applying patterns, especially if you're making a set of pieces that all have the same pattern. A decal is a pattern or image that has been printed using special ink and paper so that the image can be transferred onto a ceramic work. Decals work similar to an underglaze, in that they are applied over a glazed, fired piece, and fired or heated a third time (second time if your piece has not been bisqued) to seal the decal into the glaze.

Initially, there are two types of decals: heat transfer and water transfer. Both methods are fairly easy to use and are placed over pieces that have already been glazed and fired. Here are the instructions for applying both types of decal to your ceramic works:

Heat Transfer Decal

As the name implies, this type of decal uses dry heat to melt an adhesive attached to the decal and let it adhere to the ceramic glaze instead.

1. The first step to applying a decal is to make sure the decal fits onto your piece. You should also trim the paper around the decal to make it easier to place the design precisely where you want it.

2. Your decal will be on a carrier sheet of plastic. Place the decal on your ceramic piece, with the decal in direct contact with the ceramic piece.

3. Make sure your decal stays in place. This is fairly easy when using a flat, horizontal surface, but it may be a bit difficult on vertical or curved surfaces. You will have to hold it in place yourself, and you will need oven mitts to protect your hands from the heat.

4. Using a heat gun, expose the decal to the highest setting of heat for short intervals. Keep the heat gun two or three inches away from the decal when exposing the heat, and make sure you don't expose the decal to heat for more than five seconds at a time. If you expose the decal to too much heat at

once, your plastic carrier sheet will begin to melt and shrink, which will warp your decal.

5. After every five seconds of heat exposure, use a credit card or firm, dry sponge to make sure the decal is completely smooth and flat against your piece.

6. Keep applying heat at five second intervals until your decal has adhered fully to your piece. For smaller decals, five or six cycles should be enough (more for larger pieces). Very large pieces might need to be adhered to the piece in sections.

7. Once your decal is completely adhered, let the piece cool fully before using it.

8. As an optional step, some potters like to cover the decal with a clear glaze and firing it again, to make sure the decal is sealed onto the piece properly. If you want to do this, you need to make sure you have the right decal and glaze, as some decals might not be able to withstand the extremely high temperatures required to melt some glazes.

Water Transfer Decal

A water decal, also often called a side decal, uses water to activate an adhesive and remove it from

the paper backing. The piece is then fired at extremely low temperatures to seal the decal to the glaze.

1. Once again, make sure that your decal fits onto your piece. You may also want to trim the paper backing around the decal to make placement easier.

2. Using a damp sponge, moisten the decal until it separates slightly from the paper backing. The edges of the decal will start to curl away from the paper backing.

3. Making sure your ceramic piece is clean of any dust or oily residues, place the decal in the right position. Folding the paper backing back a little, press one of the edges of the decal to your piece and carefully slide the paper backing out from under the decal.

4. Working very carefully, as the decal is very fragile, you can slide the decal around over the surface to make sure the decal is in exactly the right position you want.

5. Use a damp sponge to smooth out all the bubbles under your decal. Remember to work carefully so you don't tear the decal. Once all the bubbles are gone, carefully dab the decal with paper towels to remove

excess water from under the decal.

6. Let the decal dry completely. If you do discover any more bubbles, use a pin to gently break the bubble, moisten the area with a bit of water, and smooth it out. Let that area dry again.

7. Once completely dry, fire the piece according to the instructions of your decal. These decals are fired at very low temperatures, usually around cone 015.

8. Let cool completely before removing from the kiln.

Most decals aren't dishwasher safe, even after firing, so make sure you read the instructions of your decal before applying the decal to any dishes.

Although decals are fairly cheap and easy to come by, you are limited by what is available in the store. Luckily, it's very simple to make your own decals with a few specialized tools. The most important of which is decal paper, which can be bought from stores or ordered online. Simply use a laser printer to print your desired image onto the decal paper. You can then apply this decal as you would a regular water transfer decal. You can use any images you want but here

are a few websites where you can get specifically designed decal images to get you started:

https://www.vecteezy.com/free-vector/decals

https://www.freepik.com/free-photos-vectors/decals

Chapter 8
China Paints

China painting refers to the technique of creating designs or patterns, through layering, on a piece that has already been glazed and fired. As the name implies, this technique is especially used for china pieces. The paints used for this technique are specially designed to act as an overglaze so they stick to the glass-like surface of the glazed work. These overglazes are called china paints and are made from ground minerals and a compound called flux, a finely ground type of glass similar to porcelain, which will melt when firing and fuse to the fired glaze. These powder mixes are the most common form in which they are sold. Potters then mix the powders with water or other liquids into a very thin paint. Ideally, the china paints are applied as a wash, meaning that a single bottle of china paint will last you fairly long. As the name implies, the most common application technique for this is painting.

China paints are fairly expensive, especially colors like purple and red which contain traces of gold. You don't want to waste it by using cheap application tools. Cheap, hard brushes can be very streaky and uneven. Cheap brushes also tend to lose hairs, which can be difficult to remove from the painted image. You'll want good quality tools that can help you reach the ultimate potential of china paints. There are tools on the market tailored for china painting, but these are expensive. If you're still new to the craft and still experimenting, you may not be ready to commit fully yet. It's best to buy a set of good quality brushes to begin with. It may still be a little pricey, but if you decide china painting isn't for you, you can use the brushes for luster glazes or underglazing.

As mentioned, the powders are mixed with liquids. There are different types of liquids that can be used for this, although oils are the suggested mediums, such as pine oil, pen oil, or baby oil. Different oils have different reactions, such as baby oil, that never completely dry and is good for mixing large batches that can be stored for later, or pen oil that is great for thinning out your paint without letting it run or bleed. Different oils dry at different speeds, provide different textures and thicknesses, and different feels to the brush strokes. For those

who are allergic to oils or don't enjoy using them, there are water-based mediums you can use. The medium you use will disintegrate during firing, so which medium you use depends purely on your preferences. The best way to find out what you like is to experiment with a few small batches using different mediums. To start off, however, you should follow the instructions provided with your china paints to familiarize yourself with the technique first.

China painting is applied just like regular underglazes, and layering works great if you use a medium that dries. Firing is also similar to other overglazes. These paints are usually fired around cone 015 to 018, but always follow the firing instructions of your specific brand of china paints. Always remember to let your piece cool completely before removing it from the kiln.

Something that might be a little troublesome with china paints is cleaning brushes. The oil and minerals of the paints tend to stick to your brushes, and a simple rinse in water won't be enough to clean your brushes properly. To get rid of the oil, you will need to use solvents, such as turpentine or acetone. However, be careful not to use harsh solvents that will damage your brushes.

Chapter 9
Triaxial Blend

Triaxial blending is a method of testing three coloring ingredients and their combinations for ceramic glazes. For this method, you will end up with at least six glazes, each in a slightly different color. The triaxial blend tests how each of the coloring ingredients work on their own and in combination with each other. It can also be used to test color mixing.

1. To start, let's label the ingredients as *ingredient A,* which will result in a red color, *ingredient B,* which will result in a blue color, and *ingredient C,* which will result in a yellow color.

2. Mix each coloring ingredient with a bit of glaze. The best way to test these glazes is to use a test tile. Place the three test tiles of the glazes in a triangle.

3. Next, mix three more glazes. In the first glaze, add one part ingredient A and one part ingredient B—this should result in a

purple glaze. Place the test tile of this glaze in the triangle between glaze A and B. Divide the size of each part so that the total of the added ingredients is the same as the amount of the single ingredient you've added to the glazes.

4. Add 1 part ingredient B and 1 part ingredient C to mix a glaze. Create a test tile—which should be green—and place it in the triangle between ingredients B and C.

5. Repeat this process with ingredients A and C—which should result in an orange test tile—and complete the triangle. This way, you can see how the ingredients react to each other and make comparisons. The Triangle should look as follows:

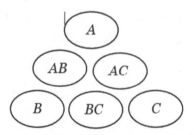

6. You can also increase the size of the triangle to test more reactions. Create a

triangle where you test two reactions for each leg between the ingredients. Test the ingredients by adding two parts ingredient A and one part ingredient B to one glaze, and one part ingredient A and two parts ingredient B in another. Place these two test tiles between ingredients one and two in the triangle. This time you will need to divide the size of the ingredients by three to maintain the percentage balance in your glaze.

7. Repeat this with ingredients B and C, and A and C. You should now have nine test tiles in total.

8. To complete the triangle, add one part ingredient A, one part ingredient B, and one part ingredient C to a glaze and place the test tile for that glaze in the center of the circle. The triangle should look like this:

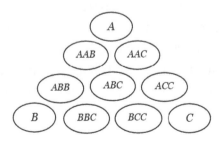

9. Fire all your test tiles and reassemble your triangle so you can compare the final results.

Although I've used the three primary colors for this example, you can use any combination of the three ingredients or colors. The point of this test is to experiment with combinations and compare them to each other. This is great for fine-tuning your own recipes to find the perfect combination for what you want.

You can increase the size of the triangle even more, though it will be a little more complicated. If, for example, you want to create a triangle with five glazes in each leg, you will make three glazes for each color combination, in order of two parts A and one part B, one part A and one part B, and one part A and two parts B. This will be repeated for every glaze. In the center, you will have three glazes instead of one, which will be a little more complicated to mix. For the glaze closest to glaze A, you will need to mix two parts A, one part B, and one part C. For the glaze closest to glaze B you will mix one part A, two parts B, and one part C. For the glaze closest to C, you will mix one part A, one part B, and two parts C. Your triangle will look like this:

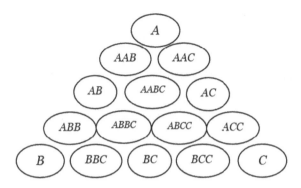

For glazes that consist of 2 parts, like *AB*, *BC*, and *AC*, you should divide the size of each part by two. For pieces that consist of three parts, like *AAB*, *AAC*, and *ABB*, you should divide the size of each part by three. For glazes that consist of four parts, like *AABC*, *ABBC*, and *ABCC*, you should divide the size of each part by for. You can also think of it in terms of halves and thirds; one part A and one part B can also be ½ part A and ½ part B, or one part A and two parts B can be ⅓ part A and ⅔ part B.

By now you have hopefully noticed a pattern that forms as you increase the size of your triangle. By using this pattern, you can increase the number of combinations to test and compare by adding more glazes to each leg of the triangle.

Just as when you do a regular glaze test, you should label your test tiles accurately, as

they won't stay in the triangle while firing, and keep careful notes of your results. You might also want to take a photo of your fired test tiles placed in your triangle, so you don't have to repeat the whole process again if you want to review your results in the future, but have sold a few of the test tiles.

Chapter 10
Specific Gravity

The term *specific gravity* is a unit that determines the consistency of a material by using the mass of a predetermined volume of said material and comparing it to the mass of the same volume of water. In ceramics, the specific mass is used to determine the thickness of a glaze, wash, underglaze, etc. There is special equipment that can be used to measure specific gravity, but there is a very simple formula you can use to measure specific gravity that won't cost you anything. This formula is the weight of the material divided by the volume of the material. As an example, 100 ml water weighs 100 g, meaning, if you divide the weight by the volume, you will have a specific gravity of 1. If you have a 100 ml glaze that weighs 150g, that glaze will have a specific gravity of 1.5.

The theory of this works simple enough, but you may not want to use a full 100 ml of glaze to find out the specific gravity, which can

make it a little more difficult to work out the specific gravity. Here are some basic steps you can follow to measure the specific gravity of your glazes.

1. First and foremost, you will need a gram scale and a container in which you are going to weigh your glaze.

2. If you have an electric gram scale that can balance the scale to zero once you've placed the container on it, you can skip this step and move to the next. Otherwise, weigh your container and write it down on a piece of paper. Keep that paper close by, as you will need it later.

3. Measure the right amount of glaze into the container—I will be using the example of 20 ml for these instructions—and weigh the glaze.

4. If you weren't able to balance your scale to 0 after placing the empty container on it, subtract the weight of the empty container from the total weight, otherwise skip to the next step. As an example, your total weight is 234 g, but your container weighs 200 g, If you subtract the weight of your container, your glaze itself will weigh 34 g.

5. Divide the weight of glaze by the volume,

i.e. 20 in this case, to find the specific gravity of your glaze. Round numbers such as 30, 40, 60, etc. are fairly easy to calculate off the top of your head, especially if you have an easy volume to work with, but for less ideal weights you may want to use a calculator for this. In the case of the example I've provided, your formula will be 34 divided by 20, meaning your specific gravity will be 1.7.

6. Make sure to keep track of your specific gravity and write it down for later use.

7. If you're measuring the specific gravity of several glazes in one sitting, make sure you properly clean and dry the container before moving on to the next glaze, as any glaze or water that stays behind can influence the weight of your glaze and lead to an inaccurate reading and your specific gravity will be wrong. This is especially problematic if you're using small volumes of glaze. You can also use a different container for each glaze, but you will have to balance your scale or weigh your container each time you switch containers.

Now that you know how to measure specific gravity, it's time you know why it's important to know what the specific gravity of

your glaze is. The main reason why you want to measure the specific gravity is to make sure your glaze is the right consistency—meaning it isn't too thick or too runny—for what you want to do with it. Dipping glazes usually have slightly lower specific gravity than glazes used for painting, while washes have much lower specific gravity than most other glazes. This is a much more accurate indication of what the consistency of your glaze should be than telling you the glaze should be as thick as milk, heavy cream, or pancake batter, as these can be relative. Some packages of powder glaze mix will tell you what the estimated specific gravity should be, and can be a great guide for beginners who haven't mastered the art of finding the right consistency by looking at the glaze.

Specific gravity is also great for making sure all the glazes you mix are all the same consistency, which can save you a lot of time, effort, and material. If you have different colors of the same brand and type of glaze mix, you can use the specific gravity to make sure that all your glazes are the same consistency. This is especially important if you plan on doing designs, images, or layering, since using a glaze that is thicker or thinner than the others can influence your application technique, and is

usually also visible after firing. Specific gravity is also great for when you've mixed a batch of glaze that ends up not being enough, and you have to mix more. Rather than mixing and trying to match the new batch to the old batch by visually comparing the consistencies and testing them both, mix a batch of glaze with the same specific gravity as the previous batch.

To help you get started with this measurement technique, here are some rough averages of the specific gravity of different glaze types. Keep in mind that some ingredient materials, especially metals, are heavier than others, and can influence what your specific gravity should be.

- Dipping glazes: 1.5–1.7

- Brushing glazes: 1.45–1.60

- Spraying glazes: 1.7–2

- Washes and stains: 1.05–1.3

- Overglazes such as luster glazes should have the same specific gravity as brushing glazes, while china paint needs a specific gravity that matches those of washes and stains.

Chapter 11

Tips and Tricks

Techniques are all good and well, but it's still easy to make a few mistakes due to ignorance and or carelessness. A few good habits, a little extra knowledge, and a hint of cleverness can help you save money, time, prevent mistakes, and bring your ceramic work to a new level in an easy and simple way. Here are 10 useful tips and tricks to help make your ceramic work look more professional:

1. **Test everything:** Even if you buy premade glazes, mix packages of glaze mix, or create your own glaze recipes, always test everything to make sure you know what you're working with. The material you are using may not exactly match the image on the packaging, or it may not look exactly like you remember it. Even if the color is the same, you may mix it to a slightly different consistency or you may use a different application technique. All of this can have an effect on your final result.

Use test tiles. Use the triaxial blend and specific gravity to help you make sure you have what you're looking for, and keep thorough records of all your tests, to help lessen the amount of testing you will have to do next time. It doesn't matter if you're using a regular glaze, soluble salt, stain, wash, luster glaze, china paint or a decal, you should still do a sample test. You should also test your clay, as well as any glazing techniques you plan on using to see if the techniques will work with the glaze and clay you're using and to see if the technique will give you the results you're looking for.

2. **Keep your brushes exclusive:** When I say this, I mean that you should have a specific set of brushes for every technique or materials you're going to use. If you use three brushes for applying a luster glaze, you shouldn't use those brushes for china paints or applying underglazes. At a quick glance, it may seem more economical to have one set of good quality brushes that you use for everything, but different materials and application techniques all have different chemical influences on your brush bristles and different cleaning methods. Combining these different

reactions and methods can cause damage and put your brushes under a lot of strain, and it won't be long before you'll need to replace them. If you keep a set of brushes for each material and method, the brushes will become better accustomed and tailored to the hardships associated with it. That way the brushes won't take on as much damage in the long run and you will also prevent overusing your brushes. This concept also works with any other application tools you want to use. If you follow this tip and take good care of your equipment in general, you can keep using the same brushes for years.

3. **Keep your layers thin:** Despite what many say, thick layers of glaze aren't always the way to go. One of the big problems is that thick layers of glaze take a very long time to dry, and they tend to be streaky. The thicker your layer of glaze, the fewer layers you can add before the piece looks bulky, and the best way to get rid of brush strokes is to use several layers painted in different directions. Overall, it's much quicker and easier to apply several thin layers rather than a few thick layers, which results in a much neater finish. Another problem is that thick layers of

glaze also cover the texture of your clay, which many potters like to keep. This can be an especially big problem if you've carved fine, intricate details into your clay before you bisque, and if your glaze layers are too thick, most of this carving work will be lost. Also, if a layer is too thick, it can become heavy and peel off your previous layer of glaze. This can be very difficult to fix, and might permanently ruin your piece completely.

4. **Have a feather touch:** While on the subject of applying glazes, you should always hold your brush lightly when painting a glaze onto your piece. Pressing too hard while painting on a glaze will just push the glaze around, and won't dispense it evenly. You can even end up scratching or picking up the previous layer of glaze, which, once again, is difficult to blend. In severe cases, you can dent greenware if you apply too much pressure. You should also be careful of very delicate clays, like porcelain, which are easy to break when they've been properly fired. Porcelain that has only been bisqued is even more fragile, and applying too much pressure could shatter your piece. Furthermore, a light touch also tends to leave fewer brush

strokes, gives you more control over your brush, and tends to have a cleaner and neater finish than a heavier touch.

5. **Use a whisk and ladle:** If you've made large batches of glaze that you store for later, there's a big chance that a large amount of your glaze has separated, leaving you with a muddy mixture at the bottom and colored water on top. You will have to give the glaze a good stir to mix the ingredients again. The best way to do this is to use a whisk. Whisk your glaze the same way you would whisk baking ingredients together. This might make your arm a little tired, but it's worth it. After whisking, there might still be some bigger chunks stuck to the bottom of your container. Use a ladle to scoop them up into the mixture again. Then use your whisk again to get rid of the last few clumps and mix everything together. Once again, keep tip number two in mind. Don't use the ladle and whisk for anything other than this purpose.

6. **Keep your glazes separate:** It's important to make sure your glazes don't accidentally mix. Because glazes are chemicals, a single drop of a different glaze can ruin your whole container of glaze in

more ways than just changing the color. Unlike regular paint, you can't just scoop out the drop of foreign glaze, the surrounding glaze, and use the rest of the glaze as the chemical process has already started and can't be undone. There are a few simple things you can do to prevent this. Firstly, if you are working with one glaze, make sure that all your other containers of glaze are sealed tightly. Secondly, work with one glaze at a time, and wash your hands and application tools thoroughly before moving on to the next glaze. Thirdly, if you're working in a studio or classroom together with other people, make sure there is enough distance between your work areas so that there is no way to contaminate any glazes. If that is impossible, let the other person finish glazing before starting to glaze yourself.

7. **Always wipe the base:** As mentioned many times before, any glaze that comes into contact with the kiln shelf will fuse to it and ruin the shelf and the piece. As such, you should always make sure the base is clear of any glaze. The simplest and easiest way to do this is to use a damp sponge or cloth to wipe any glaze off the base. You need to be very thorough when doing this,

and be careful not to remove any glaze where you don't want to. Most potters like to use a wax resist on the base. This works great, but you should still gently wipe the base in case there are areas on the base you may have missed with the resist. It is especially important to wipe the base if you've dipped the piece.

8. **Heat up the piece:** Many potters have discovered that heating the piece in the microwave for half a minute makes the glazing much easier. The glaze stays softer for longer while applying, making the brush slide smoother over the clay. The heat also helps the glaze stick to the clay better. This trick works especially well when working with china.

9. **Keep your hands clean:** You can never wash your hands enough when glazing ceramics. Any oil or residue stuck to your piece will create a space where your glaze doesn't adhere to the clay, and your glaze will peel and chip off before you can fire the glaze. The same goes for oily spots between layers of glaze. The main source of these oils and residues are your hands. Every time you touch your piece with oily hands, you create a spot where the glaze won't stick. That is why it is so important to make

sure your hands are always clean when handling your piece. Many think that they should use a sanitizer to save time, but that won't work. In some cases, sanitizers contain trace elements of oil that can stick to your glaze or the strong chemicals in the sanitizer can cause an unexpected reaction with your glaze. The only way to keep your hands clean is with soap and water, and make sure that you've rinsed off all the soap afterward.

Always clean your clay: Even when handling your clay with perfectly clean hands, you aren't necessarily ready to begin glazing yet. While drying and bisque firing, your piece may have gathered some dust, ash, or dirt, that can either prevent your glaze from sticking or cause flaws in your glaze. Wipe your piece with a clean damp cloth, and then with a clean dry cloth, to remove any unwanted dust and dirt. If you've decided to use an old piece you've never glazed, or had a coffee mishap, there's a big chance that you have some stains in the clay. Even if you could get past the glaze not sticking part, the stains can have a severe effect on the color of your glaze, especially when working on light clays. Luckily, cleaners, such as Mr. Clean Magic Erasers are great for removing tough stains from your clay.

Conclusion

Hopefully, this book has been a great help, and you've learned a few new techniques that will improve the quality of your ceramic glazes. All these techniques are simple once you understand them, and easy to master with a little time and effort. I have done my very best to make this book as straightforward and comprehensible as possible, and encourage you to experiment with the knowledge I have given you. The purpose of this book is to enable and help you learn a few more skills to use in future projects, which can hopefully make your career as a ceramic artist a little more vibrant and diverse.

References

Big Ceramic Store. (2001). Decorating with Ceramic Decals. Retrieved from https://bigceramicstore.com/pages/info-ceramics-tips-tip43_ceramic_decals

Blattenberger, M. (n.d.). A Beginner's Lesson in China Painting. Retrieved from http://www.porcelainpainters.com/ppioclass/beglesson2/page_2.htm

Britt, J. (2018). How to Do a Triaxial Blend to Test Pottery Glazes. Retrieved from https://ceramicartsnetwork.org/daily/ceramic-glaze-recipes/glaze-chemistry/triaxial-blend-test-pottery-glazes/

Britt, J. (2019). Ceramic Stains: The Easy Way to Create All the Colors of the Rainbow on Your Pottery. Retrieved from https://ceramicartsnetwork.org/daily/ceramic-supplies/ceramic-colorants/ceramic-stains-the-easy-way-to-create-all-the-colors-of-the-rainbow-on-your-pottery/

Ceramic Industry. (2000). The Science of Glazing. Retrieved from

https://www.ceramicindustry.com/articles/90432-ppp-the-science-of-glazing

Claywork Tutorials: Using Oxides. (n.d.). Retrieved from http://fireverseceramics.weebly.com/using-oxides.html

Craftibles. (n.d.). How to use Heat Transfer Vinyl on Mugs. Retrieved from https://shopcraftables.com/blog/how-to-use-heat-transfer-vinyl-on-mugs/

Earth Nation Ceramics. (2019). *Tips AND tricks for GLAZING [Video].* Retrieved from https://www.youtube.com/watch?v=6Z4KbKg7iNo&list=PLlrjOezwxajbMr3ydS35jGlvP9S2Es9yN&index=27&t=0s

Hansen, T. (n.d.). Soluble Salts. Retrieved from https://digitalfire.com/4sight/glossary/glossary_soluble_salts.html

Mallory, A. (2015). Cone 10 Layering Glazes. Retrieved from https://ceramicartsnetwork.org/ceramics-monthly/ceramic-glaze-recipes/cone-10-layering-glazes/#

Peterson, B. (2019). The Basics of Pottery Clay. Retrieved from https://www.thesprucecrafts.com/clay-basics-2746314

Pier, D. (2019). Using Rare Earth Oxides as Ceramic Colorants to Obtain Intense Colors. Retrieved from https://ceramicartsnetwork.org/daily/ceramic-supplies/ceramic-colorants/using-rare-earth-oxides-as-ceramic-colorants-to-obtain-intense-colors/

Stamps, A. (2018). Two Great Cone 6 Ceramic Glazes that Look Great Layered and On Their Own. Retrieved from https://ceramicartsnetwork.org/daily/ceramic-glaze-recipes/mid-range-glaze-recipes/two-great-cone-6-ceramic-glazes-that-look-great-layered-and-on-their-own/

Tolosa, M. (2018). Pottery Making Illustrated. Retrieved from https://ceramicartsnetwork.org/pottery-making-illustrated/pottery-making-techniques/ceramic-decorating-techniques/luster-101/#

Tulloch, K. (2015). Syracuse China: Ceramic expert offers glazing tips before Sunday's final giveaway. Retrieved from https://www.syracuse.com/entertainment/2015/05/syracuse_china_glazing_tips_for_beginners.html

Wired Chemist. (n.d.). Qualitative Analysis. Retrieved from

http://www.wiredchemist.com/chemistry/inst
ructional/laboratory-tutorials/qualitative-
analysis

CPSIA information can be obtained
at www.ICGtesting.com
Printed in the USA
BVHW062009060123
655721BV00002B/181